Contents

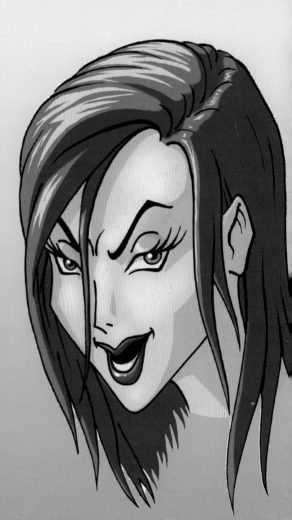

Introduction

Manga are Japanese comic books, but the world of manga now covers a whole range of media, including animes (the Japanese word for animations), computer games and graphic novels.

At the heart of any manga story are characters – both nice and nasty – and learning how to create and draw these heroes and villains is the first step for any aspiring manga artist. This book will help you understand how manga characters' heads, faces and expressions are constructed, so that you can create original drawings of your own. You will learn the subtle alterations that can turn a hero into a villain and vice versa.

Try to resist the temptation to dip into the book and just copy your favourite pictures. You'll need to get to grips with lots of principles if you want to be a good manga artist, and if you work through this book from the start, you'll be able to build up your skills gradually.

Most of all, keep in mind that drawing should be enjoyable. It may seem like hard work at times, but stick with it and you'll soon be rewarded for your efforts.

Yoshi

Yoshi is a forest sprite who inhabits remote mountain areas, only coming into our world to observe, with amusement, people's activities and to "borrow" drawing materials. (When you lose a pencil it maybe a forest sprite who is to blame!)

Like most fairy-folk, Yoshi is very highly creative and, being in tune with the natural world, is able to draw faces and figures easily and accurately. Look out for Yoshi's drawing tips throughout this book.

How to draw
MANGA
HEROES AND
VILLAINS

This edition printed in 2006

First published in 2005 by
Franklin Watts
338 Euston Road
London NW1 3BH

Franklin Watts Australia
Hachette Children's Books
Level 17/207 Kent Street
Sydney NSW 2000

Produced by Arcturus Publishing Limited
26/27 Bickels Yard, 151–153 Bermondsey Street
London SE1 3HA

© 2005 Arcturus Publishing Limited/Peter Gray

Editor: Alex Woolf
Designer: Jane Hawkins
Artwork: Peter Gray
Digital colouring: David Stevenson

A CIP catalogue record for this book is available
from the British Library

ISBN 07496 6621 8

Printed in China

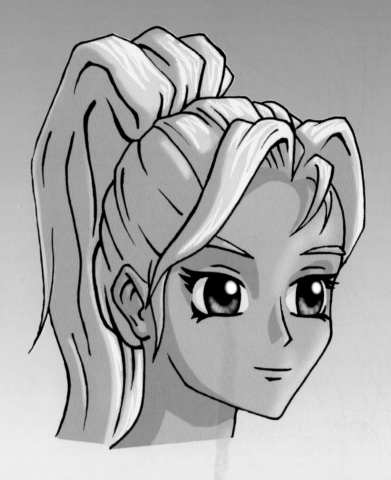

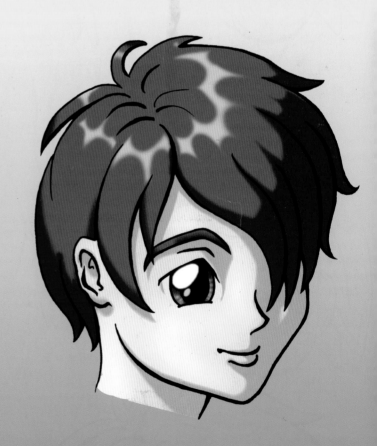

Materials

Pencils are graded H, HB or B according to their hardness. H pencils are harder and will make lighter lines. Soft pencils are graded B and will make darker lines. Most ordinary pencils used in schools and at home are HB. This is a good general-purpose pencil and perfectly good for manga drawing. However, if you can get hold of a harder pencil, like an H, this will be useful for sketching guidelines. Using this kind of pencil will make the guidelines less visible on your final drawing. You might then like to use a softer pencil, like a B, to darken the final lines of your drawings. The ideal would be a mechanical pencil. They are more expensive but produce a constant fine line. If you don't have a mechanical pencil, you'll need to sharpen your pencils regularly.

An eraser is almost as important as your pencils. It means that you can draw all the guidelines you want to help you shape your characters and then erase them later. You won't have to worry about making mistakes, either. There are dozens of different types of erasers available, but they all do the same basic job. Just make sure that yours doesn't leave behind any dirty marks.

Don't worry too much about the type of paper you use. Most of the drawings in this book were done on cheap photocopier paper. Only if you're working with paints should you purchase thicker paper since it won't tear or buckle when it gets wet.

The Head and Face

We'll start each drawing in this section by sketching some guidelines that form a framework for the head. We'll then add more guidelines for other features, step by step. You'll want to erase most of these lines at some point, so don't make them too heavy. Use your hard pencil to draw them or, if you only have a soft one, press lightly so the lines are fainter. The new lines you need to draw in each step have been highlighted in red.

Front View

Study each picture carefully to see what features you need to add.

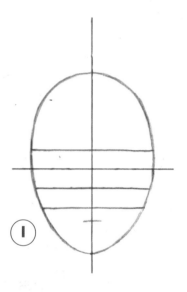

Step 1

First draw a framework for Daisy's head. Start with a vertical line. This will help you make your picture symmetrical. Draw an upside-down egg shape over this, then draw four horizontal lines across it. The longest one sits halfway down the head and the others are evenly spaced around it. Add a short pencil stroke for Daisy's mouth.

Step 2

Eyes sit about halfway down the face. First draw two arches for Daisy's irises. Use your framework to help you place them. Like most manga eyes, they are more than a whole eye's distance apart. The ears start level with the top of the eyes and finish level with where the nose will be. Add some guidelines for the hair and neck.

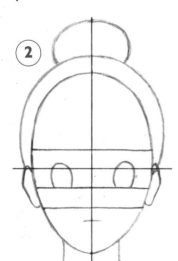

Step 3

Give the eyes and ears some more detail, then add a small, upturned nose. Shape the chin to give it a gentle, angular look.

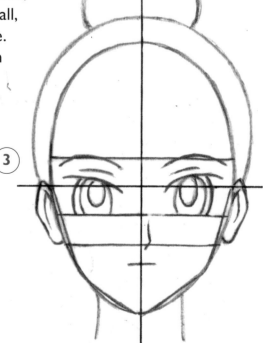

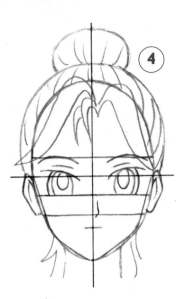

Step 4

Sketch in the rough shapes of the hair and the direction in which it flows. Here Daisy's hair is tied back.

Step 5

Give the hair, eyes and eyebrows more detail. Add a small circle to each eye to make a bright highlight.

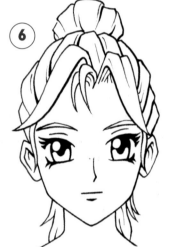

Step 6

Now go over your pencil lines with a black ballpoint or felt-tip pen. Use smooth, confident strokes. Shade in her pupils as well as the top half of each iris since this part is in the shadow of the eyelid. Leave the bright highlights white. Add the eyelashes, too. Once the ink is dry, rub out any remaining pencil marks, including the ones that made up your original framework.

Step 7

If you want to add colour, you might like to copy this colour scheme.

The precise position and size of a person's eyes on the face change with age. Children's eyes are larger and sit lower on the head than adults' eyes.

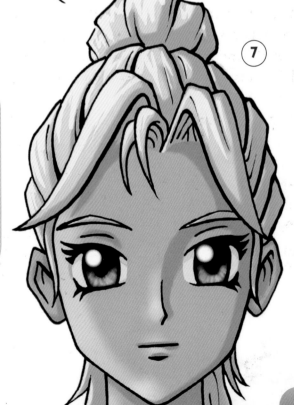

7

Profile

Daisy's head looks more circular when it is drawn from the side.

Step 1

To make a framework, draw a circle, then attach a pointed shape to the bottom left of this to form the face and jaw. Draw a horizontal line across the centre of the whole shape, then add three more horizontal lines. Make a short pencil stroke for the mouth.

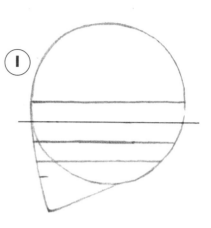

Step 2

Use the guidelines to help you place Daisy's eye and ear. From this angle, the iris takes the shape of a narrow arch and sits close to the front of the face. The ear is just over halfway back on the side of the head. To draw the outline for the hair, it may help you to extend your main horizontal guideline. Notice how the neck slopes backward.

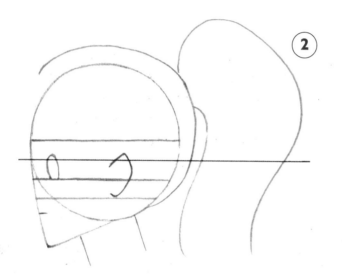

Step 3

Shape the front of Daisy's face, then soften the line forming the underside of her chin. Now add some detail to the eye and ear.

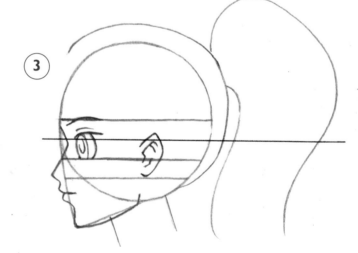

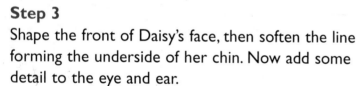

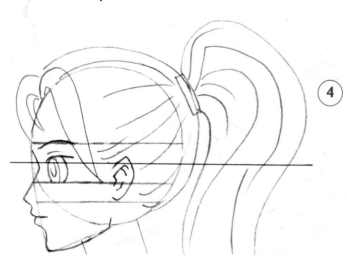

Step 4

Study the picture to make sure your guidelines for the hair show the different directions in which it flows.

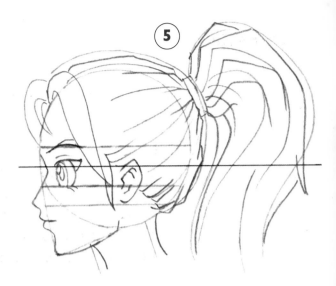

Step 5

Work on the hair to make it more angular. This is a key feature that distinguishes manga artwork. Add more detail to the eye and give an outline to the neck.

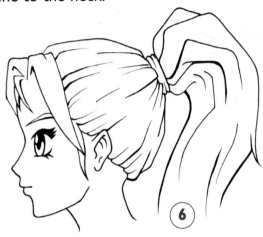

Step 6

When you're ready, go over your pencil lines in pen, as you did for the previous drawing. Let the ink dry, then erase all remaining pencil lines to leave a clean picture.

Outlining your drawing using black felt-tip pens of different thickness will allow you to make some lines heavier than others, adding solidity to your picture.

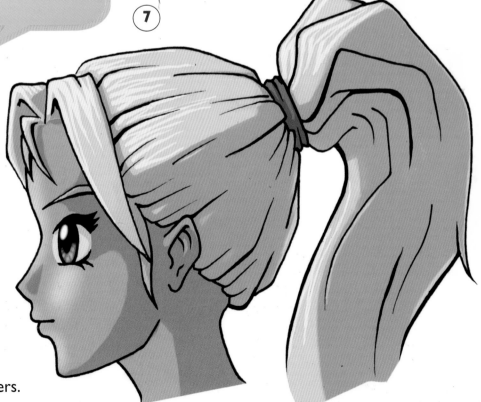

Step 7

Now add colour if you wish. Notice how some parts have been shaded darker than others.

3/4 View

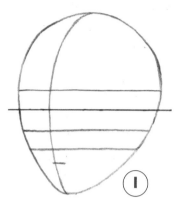

Daisy has turned her head so that we can see the front and the side.

Step 1
Draw a shape that's like a pointed egg standing upside down and tilting to the right slightly. Notice how the vertical guideline curves. Add four horizontal guidelines as before and a tiny one for the mouth.

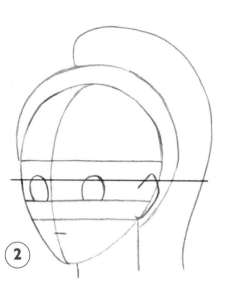

Step 2
The eye on the left of the picture is slightly angled away from us, so make the arch of the iris narrower and place it closer to the vertical guideline than the other eye. Place the ear, hair and neck.

Step 3
Add some detail to the eyes and ear. To draw the nose, start above the eyebrows and draw a long curve ending in a little point. Reshape the jawline to make it more angular.

Step 4
Draw the guidelines for Daisy's hair. Notice how one piece falls across the eyebrow. Don't worry that your pencil lines overlap each other; you'll erase unwanted lines later.

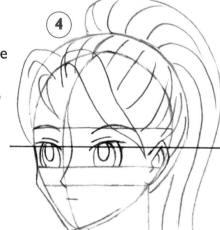

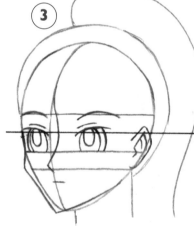

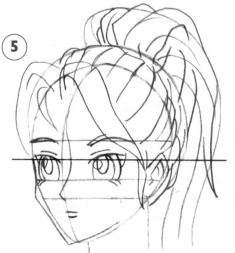

Step 5
Give the hair more shape, then work some more on the eyebrows, eyes and mouth. When you mark the bright highlights on Daisy's eyes, make the one on the left oval-shaped rather than round.

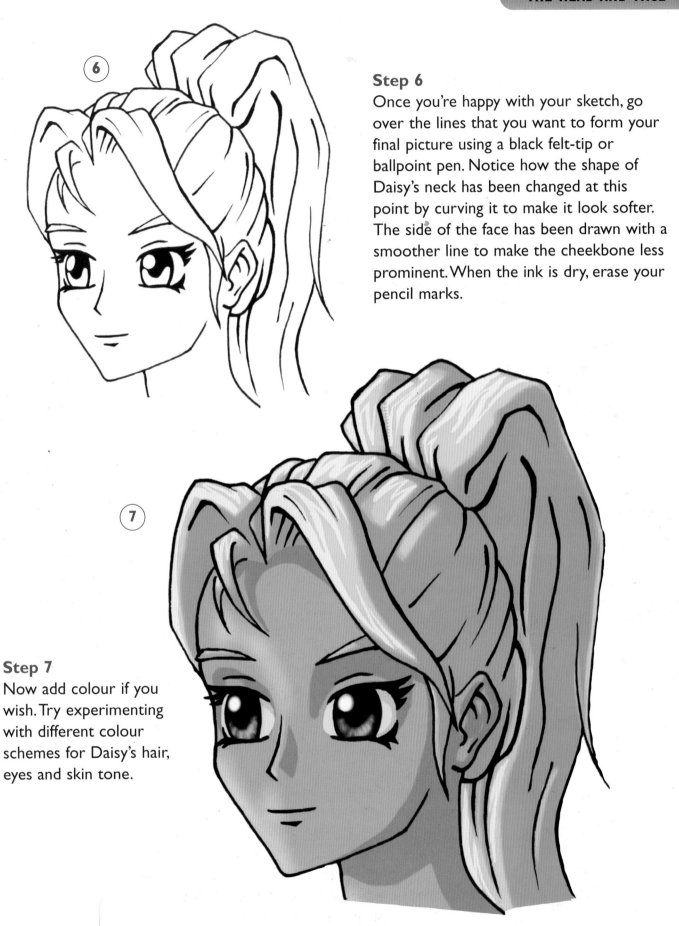

6

Step 6
Once you're happy with your sketch, go over the lines that you want to form your final picture using a black felt-tip or ballpoint pen. Notice how the shape of Daisy's neck has been changed at this point by curving it to make it look softer. The side of the face has been drawn with a smoother line to make the cheekbone less prominent. When the ink is dry, erase your pencil marks.

7

Step 7
Now add colour if you wish. Try experimenting with different colour schemes for Daisy's hair, eyes and skin tone.

Expressions

The human face can show many different kinds of emotion. Good comic artists use their characters' moods and reactions to help tell the story. Here Daisy is showing some of the expressions that are common in manga comic books.

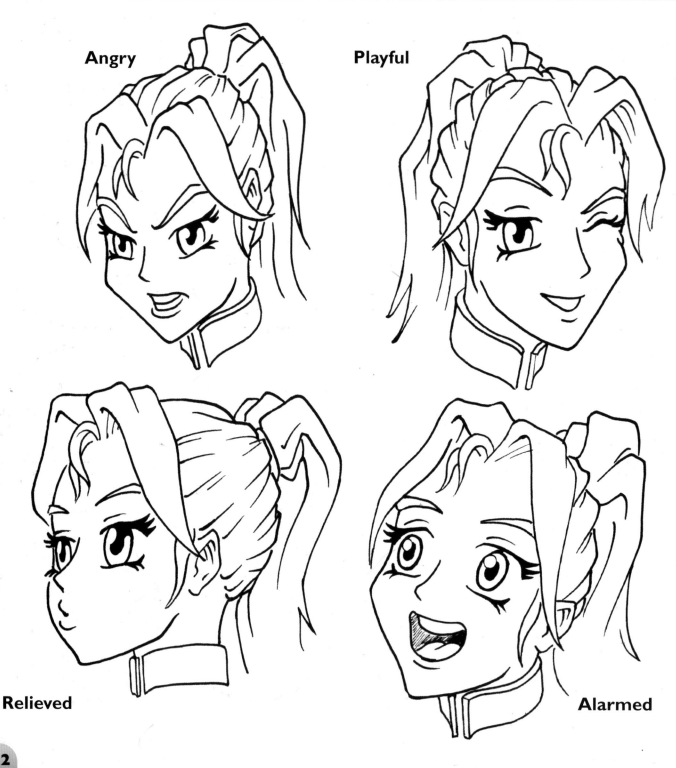

Angry

Playful

Relieved

Alarmed

Simple changes

You should be able to tell what each of these faces is expressing right away, even though each picture is made up of only a few simple lines and circles. Now practise drawing them.

Note how very simple changes – the tilt of an eyebrow or the drop of a lip – can bring about a complete change of mood.

Eyes

When you are drawing manga eyes, keep in mind that the eyeball is round. It doesn't always look like it because some parts are hidden by the eyelid. Nearly all manga eyes have a white spot on them – a bright highlight to make them look shiny.

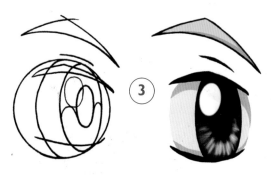

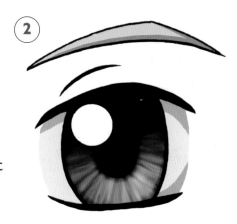

1–2 Looking straight ahead

The eye has a round iris (the coloured part of the eye) and a round pupil (the black spot in the middle). The top part of the iris is shaded black because the eyelid is casting a shadow over it. The bright highlight is left white.

3–4 Turning away

When a head is turned away, we can see more of the white part of the eye. The iris, pupil and white highlight will all sit further to the right. To draw a narrow eyeball, start with a circle, then add a curved line to it just in from the left. Think of this curve as where the skin covers the eyeball.

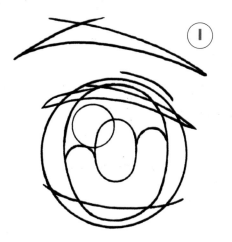

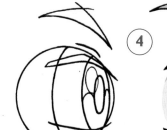

5 Evil eyes

Changing the shape and details of the eyes can immediately turn a hero into a villain. Cover up more of the eye with the eyelids and make the iris and pupil smaller.

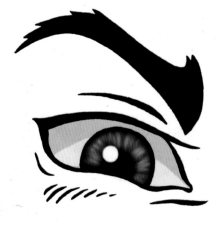

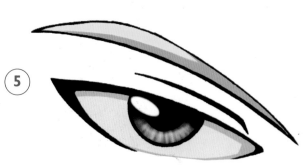

6 Expressive eyes

Eyes can say a lot about a person. Here are some pictures of Daisy's eye to show you how it can be drawn differently to illustrate what she is doing or how she is feeling.

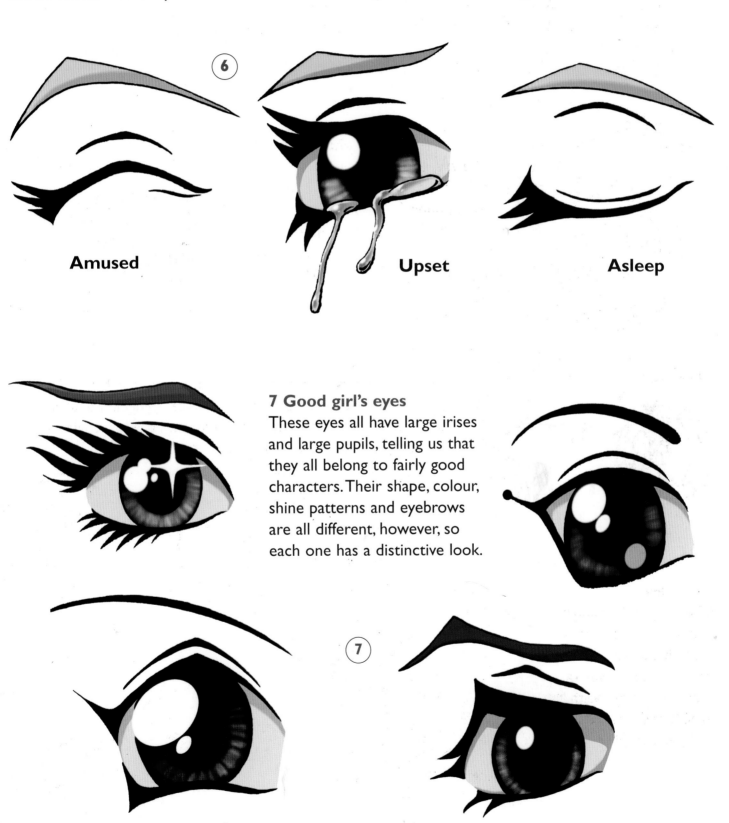

Amused

Upset

Asleep

7 Good girl's eyes

These eyes all have large irises and large pupils, telling us that they all belong to fairly good characters. Their shape, colour, shine patterns and eyebrows are all different, however, so each one has a distinctive look.

Good and Bad Characters

Inventing characters is one of the most rewarding aspects of drawing. Here are a few examples.

Heroes

You know these are good guys and girls because they have large pupils, even when they have small irises, and their expressions are soft. You can tell they have different strengths, weaknesses, interests and attitudes. It all shows in their faces.

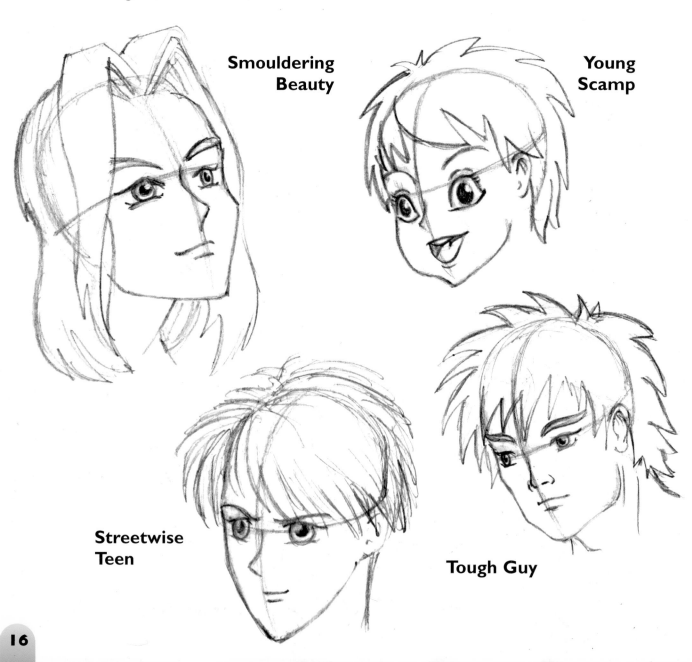

Smouldering Beauty

Young Scamp

Streetwise Teen

Tough Guy

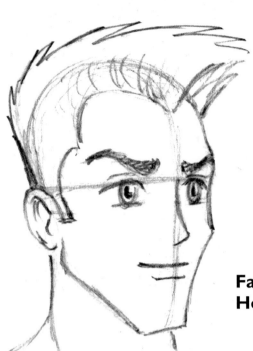

Fantasy Hero

Dreamer

Minx

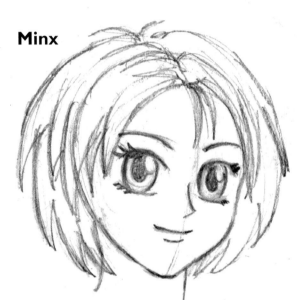

Schoolboy

Try drawing each of these characters or make up some of your own. Try changing the expressions, whilst retaining the friendly features of each face.

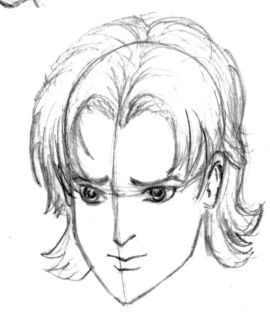

Serious Type

Villains

Most bad guys and girls have tiny pupils and dramatic eyebrows. After you've tried drawing the examples on this page, how about inventing some villains of your own?

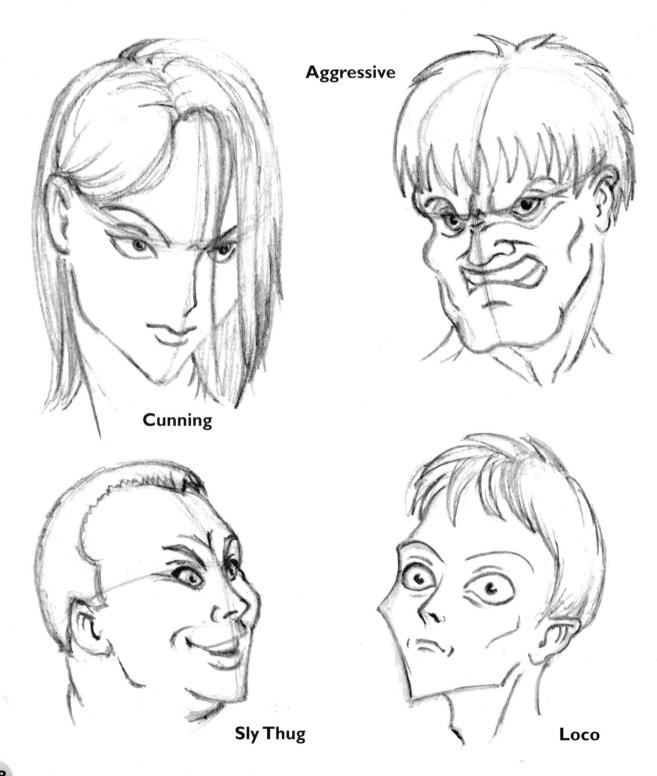

Aggressive

Cunning

Sly Thug

Loco

Manic

Freaky

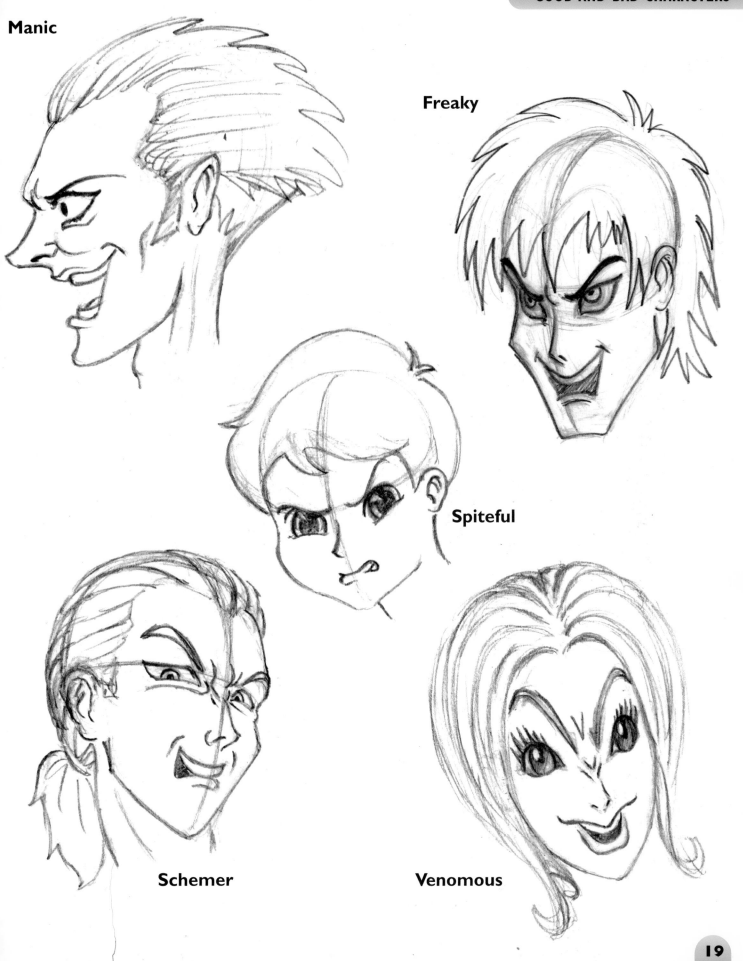

Spiteful

Schemer

Venomous

Duke and Dagger

Here is Duke and his evil twin Dagger. By comparing these pictures of the manga twins, you can see that just a few small alterations to Duke's facial features turn him from a kind and innocent teenager into a mean and aggressive bad guy!

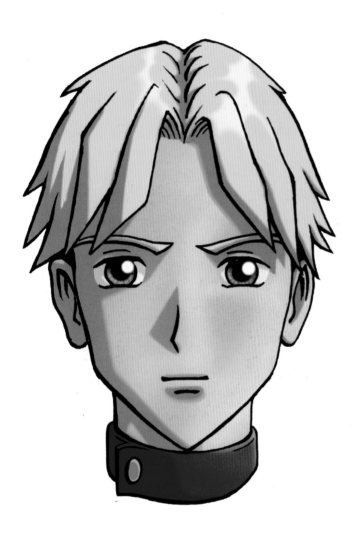 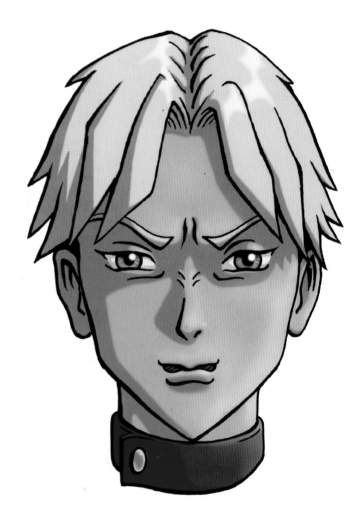

Drawing hints

To differentiate Dagger from Duke, make the eyes narrower and give them smaller pupils. Angle the eyebrows down toward the centre and draw two deep frown lines in between them. Add some little lines at the top of the nose to show that Dagger is sneering. Now change the shape of the mouth so Dagger is curling his bottom lip. Subtle changes to the colour and shading add to the effect too. A dark shadow is now cast across the eyes.

Daisy and Detta

Now take a look at Daisy and her evil twin, Detta. Notice how just a few small alterations to Daisy can change her from a friendly and helpful teenager into a cold and scheming bad girl!

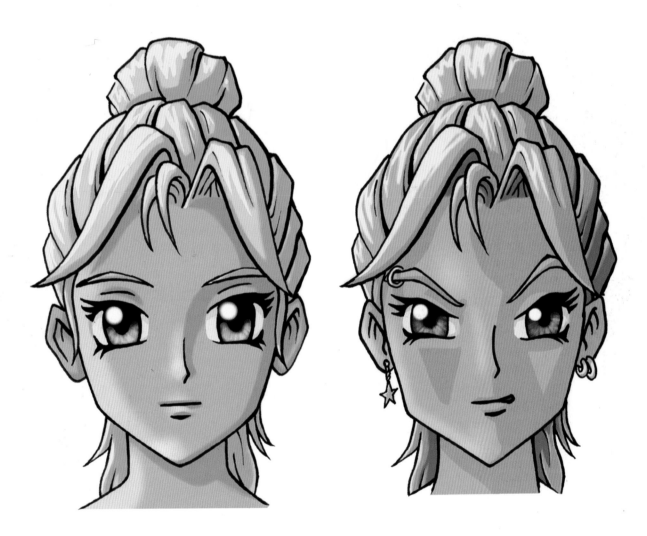

Drawing hints
Give Detta's eyes less height and make the pupils smaller. Angle the eyebrows down toward the centre, and curl the lip at one end to make Detta scowl. Give her lots of earrings and put a ring through one eyebrow. If you decide to colour in your picture, add some darker patches to her face to cast shadows across it. Make her eyes more grey than Daisy's. Use a dirtier yellow for the hair.

Projects

The exercises in this final section will give you the chance to put into practice the techniques you've learned so far. By all means refer back to other sections of the book for guidance at any stage. Hopefully these projects will inspire you to start creating some heroes and villains of your own.

Good Girl Hale

Females of different ages have different characteristics, but the techniques you use to draw them are the same.

Step 1
Hale is much younger than Daisy. Her head is rounder, so start by drawing a circle instead of an egg shape. We'll draw her looking down and to the right, so your vertical guideline should curve out to the right. Place three horizontal guidelines as shown. They curve upward at the ends.

Step 2
Place the large irises of Hale's eyes as shown. Remember that from this angle, one will appear thinner than the other and it will sit nearer to the vertical line. Draw a small ear and two long, thin eyebrows.

Step 3
Add some detail to the eyes and ear, then draw on the nose and mouth.

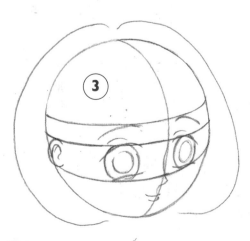

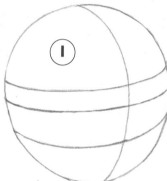

Step 4
Make the bottom of the hair more jagged and draw some longer pieces of hair around the sides of the face. Don't cover up the ear. Place a large bow on top of the head.

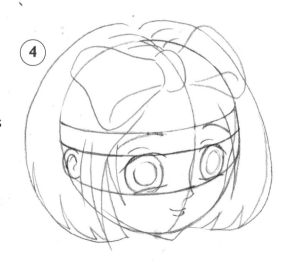

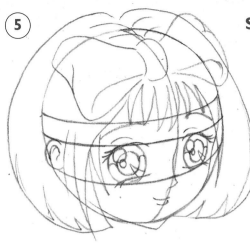

(5)

Step 5

Add a fringe, then work on the eyes and eyelashes. Each eye has three bright highlights. Two are circle-shaped and sit in the top left of the eye. The third looks like a little fang and sits in the bottom right.

Step 6

Go over the light pencil lines with heavier lines, erasing the lighter lines as you go. Add some lines to show the gathers on the bow. Shade in Hale's pupils as well as the top part of each iris, but make sure you leave all the bright highlights white. Now ink over your picture. Leave it to dry, then erase the rest of your pencil lines.

(6)

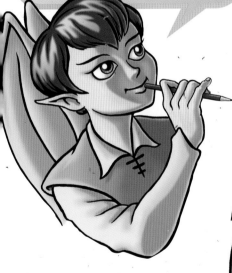

Young characters like Hale have plenty of space for more than one bright highlight in each of their huge eyes! The highlights can form a whole range of patterns.

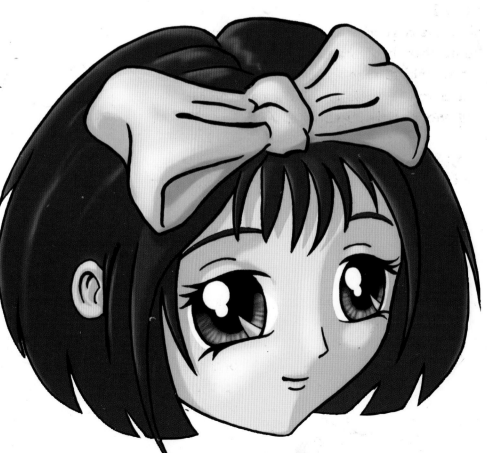

(7)

Step 7

Now you can add colour, if you wish.

Good Boy Jai

Jai is a young character. Like Hale, his proportions are different from those of an older person. Notice how he differs from the drawing of Duke (page 20), who is seventeen.

Step 1
Copy the framework for Jai's head as shown. The horizontal guideline will still sit halfway down the shape, but since Jai is looking down slightly, the ends of this line will curve upward.

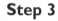

Step 2
Jai's eyes are large in relation to his other facial features. One eye is hidden by his hair, but the one we can see has a large oval-shaped iris.

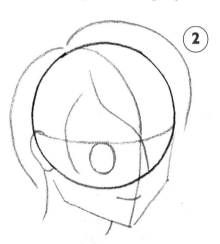

Step 3
Add the detail to Jai's eye and draw a large eyebrow. His nose is smaller than Duke's, so make it short and rounded. Soften the jawline.

Step 4
Now work on Jai's floppy hairstyle. He has a side parting. Notice how this affects the way the hair falls.

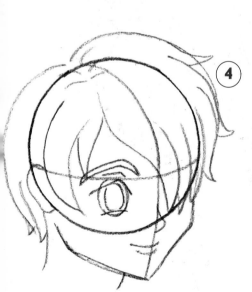

Step 5
Jai has two bright highlights on his eye. A large almond-shaped one fills the top corner and a second one, shaped like a tiny oval, sits underneath this. Add further detail to his ear and hair.

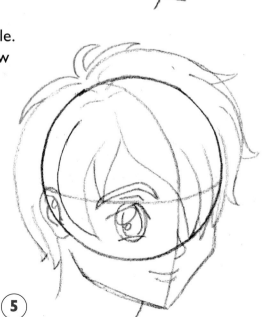

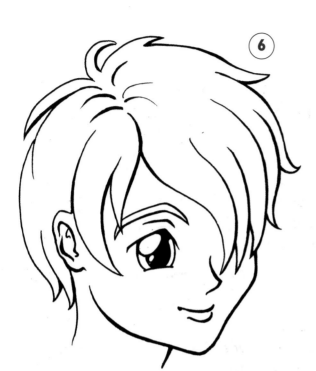

Step 6

Ink over your picture. Shade in Jai's pupil, making sure you leave the bright highlights white. Leave it to dry, then erase any pencil lines that formed the original framework for the head.

Step 7

If you add colour to your picture, try making the smaller bright highlight a light blue instead of white. Make some areas of the hair paler to show the way the light hits the hair.

Bad Girl Ruelle

This character is a grown-up woman, and an evil one at that. We'll be drawing a 3/4 view of her.

Step 1

Start with a long egg shape that is pointed at the bottom and tilts to the right. Add a vertical line that curves out to the left. Notice that the two horizontal lines curve up at the ends since Ruelle's head is tilted down slightly.

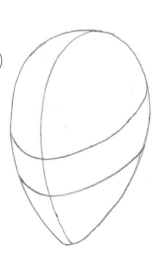

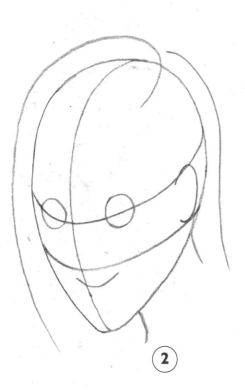

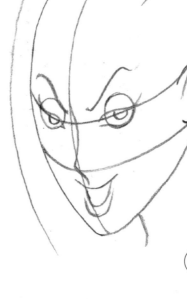

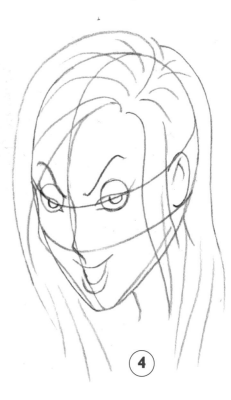

Step 2

Draw Ruelle's eyes across the top horizontal line so they sit high up on her head. Add a large curved ear. Place the mouth, neck and hair.

Step 3

Add some more detail to the facial features. Notice how low down the top eyelids are, making the eyes look heavy. The eyebrows are sharply angled and the nose long and narrow. Draw the mouth open.

Step 4

Reshape the face to make the cheekbone jut out more. The jaw shape is long and narrow. Add some lines to define the lank hair.

Step 5

Add a strip of hair falling across Ruelle's face and reshape the ends to make them more straggly. Add lines to the crown of her head. Give her long eyelashes, but make her pupils small. Thicken the eyebrows and shape the lips.

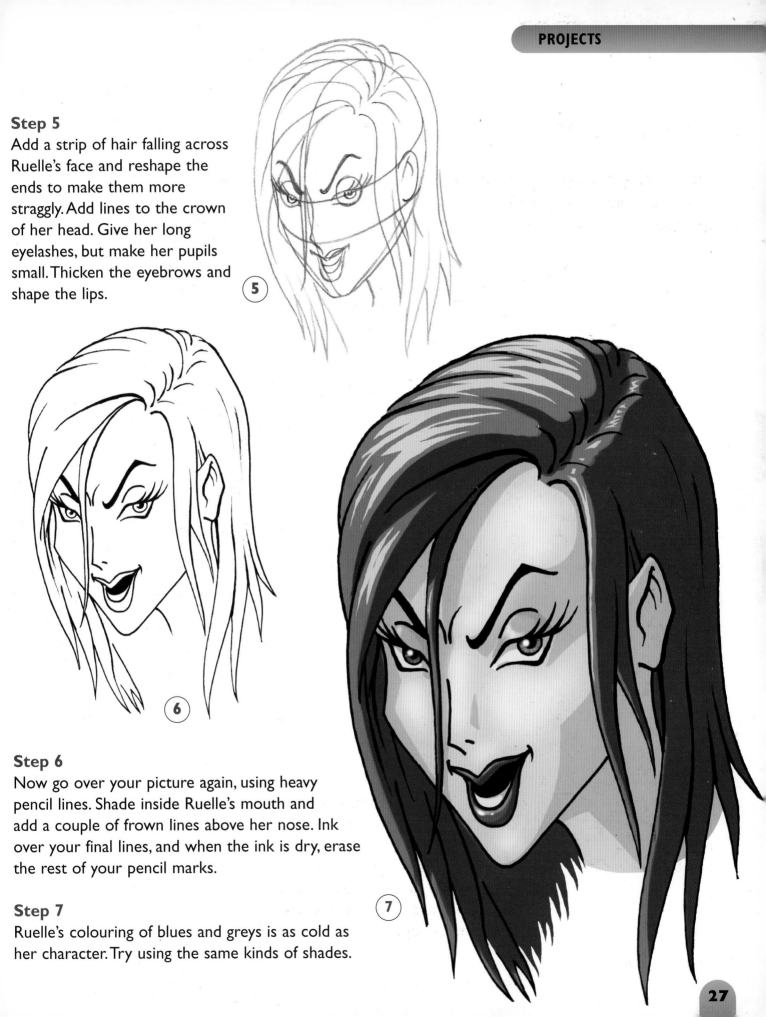

Step 6

Now go over your picture again, using heavy pencil lines. Shade inside Ruelle's mouth and add a couple of frown lines above her nose. Ink over your final lines, and when the ink is dry, erase the rest of your pencil marks.

Step 7

Ruelle's colouring of blues and greys is as cold as her character. Try using the same kinds of shades.

Bad Guy Bile

Getting the framework for Bile's head right is the key to creating this evil character.

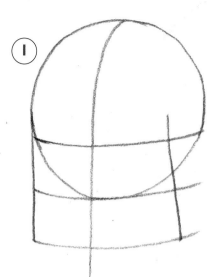

Step 1
Start by drawing a circle with a vertical guideline curving down from the top. Copy the other vertical guidelines. Add the horizontal guidelines. They should curve slightly as shown.

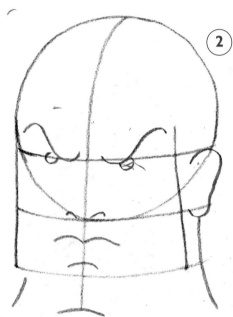

Step 2
Draw two small circles for the irises of Bile's eyes. Notice how one sits slightly higher than the other. Copy the curves of the eyebrows. Draw the first lines of the nose, mouth and ear and add the thick-set neck.

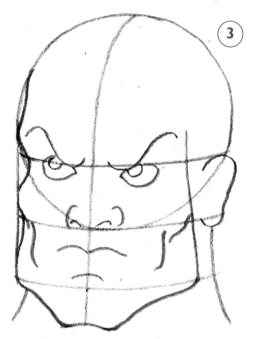

Step 3
When you draw Bile's eyeballs, position them so that the irises sit high up inside them. Copy the crooked shape of Bile's face and jaw. Add two little curves to form the edges of his wide nostrils.

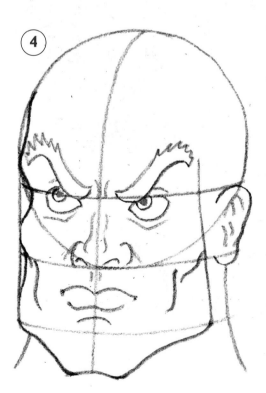

Step 4
The eyebrows really make Bile's face look mean here. Make them jagged along the top to show how hairy they are. Don't forget the lines that create bags under his eyes. Add lines to the ear, nose, mouth and eyes, as shown.

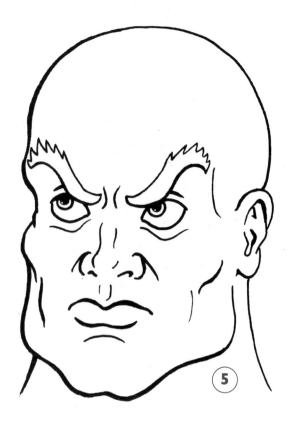

(5)

Step 5
Now ink over your heavy pencil lines. Go over some of the lines twice to make them bolder. When the ink is dry, erase any remaining pencil lines.

(6)

Step 6
Now you can have some fun with colour. Bile has been coloured a sickly green with a tinge of grey added around the eyes. The orange eyebrows look like they're on fire.

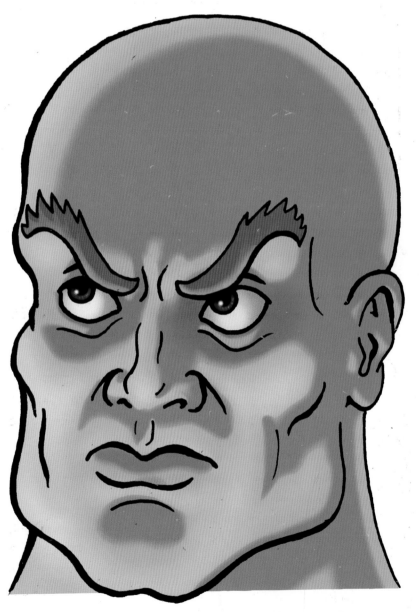

Glossary

angular Having angles or sharp corners.

buckle Bend out of shape, warp or crumple.

differentiate Show the difference between two things.

distinctive Different.

framework Structure.

highlight *noun* An area of very light tone in a painting that provides contrast or the appearance of illumination.

highlight *verb* Draw attention to something, or make something particularly noticeable.

horizontal Parallel to the horizon.

iris The coloured part of the eye.

loco Mad or irrational.

manga The literal translation of this word is "irresponsible pictures". Manga is a Japanese style of animation that has been popular since the 1960s.

manic Extremely excited or tense.

proportion The relationship between the parts of a whole figure.

pupil The dark area in the centre of the eye.

scamp A mischievous person.

scowl Express anger or menace by drawing the eyebrows together towards the middle of the forehead.

smouldering Slow-burning.

venomous Poisonous.

vertical Upright, or at a right angle to the horizon.

Further information

Books

The Art of Drawing Manga by Ben Krefta (Arcturus, 2003)

How to Draw Comic Book Bad Guys and Gals by Christopher Hart (Watson-Guptill Publications, 1998)

How to Draw Comic Book Heroes and Villains by Christopher Hart (Watson-Guptill Publications, 2001)

How to Draw Manga: A Step-by-Step Guide by Katy Coope (Scholastic, 2002)

How to Draw Manga: Compiling Characters (Volumes 1 & 2) by the Society for the Study of Manga Techniques (Japan Publications Trading Company, 2000)

Step-by-Step Manga by Ben Krefta (Scholastic, 2004)

Websites

http://www.polykarbon.com/
Click on "tutorials" for tips on all aspects of drawing manga.

http://omu.kuiki.net/class.shtml
The Online Manga University.

http://members.tripod.com/~incomming/
Rocket's How to Draw Manga.

Note to parents and teachers:

Every effort has been made by the publishers to ensure that these websites are suitable for children and contain no inappropriate or offensive material. However, because of the nature of the Internet, it is impossible to guarantee that the contents of these sites will not be altered. We strongly advise that Internet access is supervised by a responsible adult.

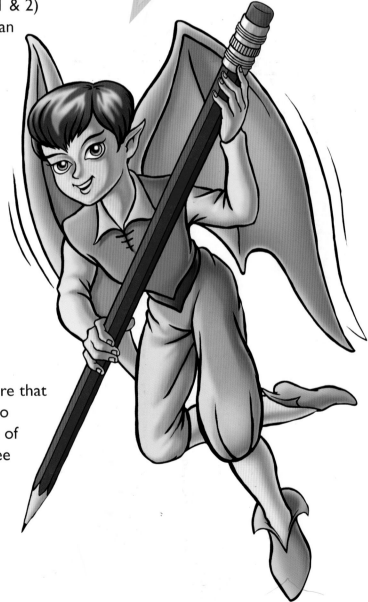

'Bye everyone! I hope you had fun learning how to draw manga.

Index